THE **MUSEUM** OF **BAD ART**

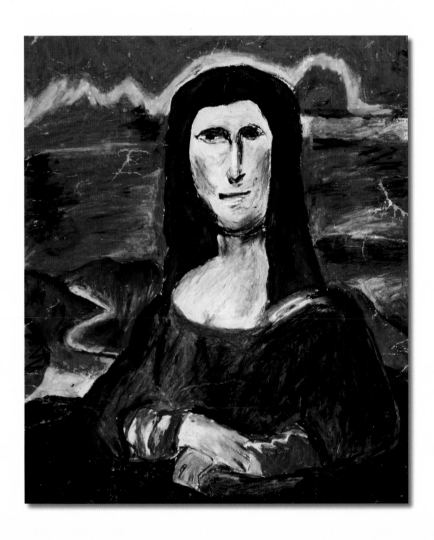

THE
MUSEUM
OF
BAD ART
MASTERWORKS

MICHAEL FRANK and
LOUISE REILLY SACCO

TEN SPEED PRESS
Berkeley | Toronto

Ten Speed Press
PO Box 7123
Berkeley, California 94707
www.tenspeed.com

Distributed in Australia by Simon and Schuster Australia, in Canada by Ten Speed Press Canada, in New Zealand by Southern Publishers Group, in South Africa by Real Books, and in the United Kingdom and Europe by Publishers Group UK.

Cover and text design by Chloe Rawlins

Image on page 62, from *How to Paint with Casein, Watercolors, Tempera, Gouache, and Oils*, by Eugene M. Frandzen (1960), used with permission of Walter Foster Publishing, Inc.

Quotation on page 12, from "A Piece of Cake" by Michelle Lovric, published in *Lady* magazine (September 12, 2006), used with permission from the author.

Library of Congress Cataloging-in-Publication Data

Frank, Michael (Michael J.), 1948–
 Museum of Bad Art : masterworks / Michael Frank and Louise Reilly Sacco.
 p. cm.
 Summary: "A photographic collection of more than seventy pieces of master artwork, including artistic commentary, from the permanent collection of the Museum of Bad Art (MOBA) in Boston, Massachusetts"—Provided by publisher.
 ISBN-13: 978-1-58008-911-1
 ISBN-10: 1-58008-911-9
 1. Museum of Bad Art—Catalogs. 2. Art—Massachusetts—Boston—Catalogs.
I. Sacco, Louise Reilly. II. Title.
 N521.M87A62 2008
 708.144'7—dc22
 2007048702

Printed in China
First printing, 2008

1 2 3 4 5 6 7 8 9 10 — 12 11 10 09 08

Contents

The Art

Introduction

Welcome to the Museum of Bad Art (MOBA), a unique institution occupying a niche previously ignored in the international community of art collection, preservation, and interpretation. MOBA exists to celebrate the labor of artists whose work would be displayed and appreciated in no other forum.

About MOBA

In 1994, arts and antique dealer Scott Wilson spotted and rescued a painting from a curbside trash pile. He intended to discard the painting and sell the frame, but his friend Jerry Reilly saw the painting and insisted that he wanted it—frame and all.

When Mr. Wilson found another equally lovely piece, he brought it to Mr. Reilly immediately, and the Museum of Bad Art was born.

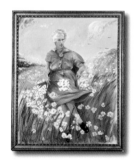

Originally housed in Mr. Reilly's basement, the collection grew quickly and attracted the attention of kindred spirits: people with indisputably bad art that demanded an audience. Soon Mr. Reilly's wife, Marie Jackson, began writing brief blurbs for the pieces to help their friends appreciate the art. They decided to publish a virtual museum on CD-ROM and develop a website. Photographer Tom Stankowicz joined the founding team, as did business consultant (and Mr. Reilly's sister) Louise Reilly Sacco. The founders, earning no salary, were encouraged to select their own titles.

Scott Wilson, esteemed curator
Jerry Reilly, executive director
Marie Jackson, director of aesthetic interpretation
Tom Stankowicz, director of imaging and reproduction
Louise Reilly Sacco, director of financial enablement

When the founders retired from the museum to focus on their growing families, Ms. Sacco assumed the role of acting interim executive director and was soon promoted to permanent acting interim executive director. After a worldwide search, Michael Frank, an active MOBA volunteer who had headed the Marching MOBA Kazoo Band at the first MOBA auction, was selected as curator-in-chief. Among Mr. Frank's qualifications: he had donated more pieces to the collection than anyone besides Mr. Wilson—and he owned a tuxedo.

After articles in *Rolling Stone*, *Wired*, and the *Wall Street Journal* brought worldwide attention to Mr. Reilly and Ms. Jackson's basement, the museum moved to a 1927 art-house movie theater outside of Boston. Currently located within earshot of the men's room in a basement space large enough to exhibit more than forty paintings, MOBA is open whenever films are showing upstairs. Admission to the gallery is always free.

There are over four hundred pieces in the permanent collection. Many have been purchased at yard sales, secondhand stores, and thrift shops. Some pieces were donated by the artists who created them, and others were rescued from municipal solid-waste disposal systems. While MOBA does not sell works out of the permanent collection, it does from time to time

trade with bARTerSauce.com, a Seattle-based experiment in trading that focuses on art and odd objects.

Like all reputable museums, MOBA is happy to accept donations. Enquiries regarding possible submissions should be made via email (Curator@MuseumOfBadArt.org). People who send pieces to MOBA need never worry about seeing them lying around the attic or garage again. Works not accepted into the permanent collection are not returned but added to the rejection collection and sold at auction.

When Curator-in-Chief Michael Frank is asked to elucidate criteria for accepting artwork into the permanent collection, he often responds, "Bad art is like pornography in that, while I find it difficult to articulately define it, I know it when I see it." Unfortunately, many people mistakenly infer that he likes, often sees, and is an expert on pornography. While there are some images of naked people in this book, the rationale for their inclusion is that they demand our attention in a non-prurient and nonlubricious manner.

MOBA has been featured on CNN, *Good Morning America*, *The Today Show*, and *Bravo Canada*, and in hundreds of other television, radio, and print outlets across the United States, Brazil, Turkey, Japan, Sweden, Greece, South Africa, Indonesia, and more. Despite the worldwide attention, MOBA senior staff was dismayed and puzzled to be ignored by the supermarket tabloids until an article in the *National Enquirer* attracted substantial attention. Our first book, *The Museum of Bad Art: Art Too Bad to Be Ignored* (Andrews McMeel) was published in 1996, and as this book goes to press, a documentary film about the museum is underway.

MOBA Standards

The principal principle for a work of art to be accepted by MOBA is that it must have been created by someone who was seriously attempting to make an artistic statement—one that has gone horribly awry in either its concept or execution. An artist's poor technique does not ensure a painting's acceptance into the collection unless the lack of drawing ability, perspective, or sense of color results in a compelling image (*Dog Bites Man*, *Annie's Downstairs Secret*). Sometimes there is evidence that the artist possesses technical command but has either purposefully or inadvertently made some mistakes (*No Visible Means of Support*, *Elián González's Grandmothers*). There are also pieces with unusual themes, prompting viewers to scratch their heads in wonder (*Prosthetic Claw*, *Charlie and Sheba*). Some of the most remarkable works are those containing over-the-top imagery, whether or not the artist's intent is decipherable (*Long Arm of the Law*, *Invasion of the Office Zombies*).

While the provenance of a particular piece is sometimes difficult to ascertain, MOBA does not collect the work of young children, nor paintings on black velvet, paint-by-numbers, or completed latch hook kits. Commercially produced paintings are not considered, nor are the works of artists cranking out paintings for tourists.

Any of the aforementioned may be compelling but are probably better suited for the Museum of Questionable Taste, the International Schlock Collection, or the National Treasury of Dubious Home Decoration.

Clockwise from top left: velvet, paint-by numbers,
work by children, kitsch, tourist art, and craft

Crimes Against MOBA

In 1996, MOBA's iconic treasure *Eileen* was stolen. After reporting the theft to the police and notifying newspapers and art dealers, the museum offered a reward, which rose to almost $37 thanks to generous MOBA supporters. Everyone feared *Eileen* might be locked away for the private enjoyment of a twisted art aficionado or consigned to the public refuse system, but all hoped for her safe return.

Ten years later, someone who claimed to have knowledge about the caper contacted the museum and asked for a $5,000 ransom. MOBA subscribes to the highest level of museum ethics so refused to negotiate. Authorities eventually crafted a complex agreement under which the kidnapper would not be charged with any crime as long as the painting was

safely returned. *Eileen* is once again safe and snug in MOBA's storage vault.

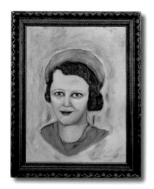

EILEEN
R. Angelo Le
24" x 18". oil on canvas
Salvaged from a curbside trash pile in Boston
MOBA catalog #070

Remarkable in its simplicity. this passionate portrait of a girl with green eyes appeals to every emotion. Which passion was uppermost in the painter's heart? Knife stroke follows brushstroke. This is an infinitely interesting and disturbing neoprimitive portrait.

In 2004, someone snatched *Self-Portrait as a Drainpipe* from the museum and left in its place a crude ransom note demanding $10 for the return of the drawing. Probably aware of MOBA's long-standing policy against negotiating with criminals, the thief neglected to include contact information. MOBA's security staff waited anxiously for further communication and was happy to take the credit when the work mysteriously reappeared on the gallery wall with a fresh ten dollar bill taped to the glass.

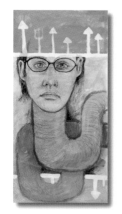

SELF-PORTRAIT AS A DRAINPIPE
Miranda
22" x 11". tempera on cardboard
Salvaged from a curbside trash pile in Boston
MOBA catalog #261

Who knows what moves an artist to portray herself as a plumbing fixture?

MOBA's Artistic Commentary

Most people have opinions about art but need the assistance of experts to truly understand it. Stone tablets illustrate the debate among French cavemen about the portrayal of animals in the Paleolithic Lascaux Cave paintings (15,000 BC). The field of art interpretation developed through the ages and continues to this day; a cadre of educated professionals helps the masses appreciate what others have created. Experts (historically known as "art critics" or "mavens") decide which works of art are important and why they are valuable. "Personal art shoppers" advise well-heeled clients about which pieces will be even more valuable in the future.

There is unknowable truth in art. We will never know for sure what Mona Lisa found so amusing, whether Johannes Vermeer was carrying on with the maid wearing the pearl earring, what Jackson Pollack was looking for when he accidentally knocked over a shelf full of open cans of paint, or whether Andy Warhol had an unauthorized prerelease beta version of Photoshop. It is the responsibility of art interpreters to stroke their chins, ask insightful questions, use pretentious vocabulary, and offer everyone else assistance in understanding reality.

Bad art holds as much hidden meaning as Renaissance, impressionist, Dadaist, surrealist, cubist, modern, postmodern, or performance art, or any other category of creative endeavor. There is, therefore, a short commentary about each image, designed to offer insightful direction toward appreciation of each of the works in this collection. Some of the works are so

enigmatic that merely *interpreting* their significance is insufficient; the works demand to be *interpretated*.

Since the dissolution of the MOBA interpretative staff—yet another episode of the downsizing epidemic rampant among many of our cultural institutions—the curator-in-chief and lovely acting permanent interim director have assumed the role of head interpretators rather than outsource the responsibility to poorly paid experts on other continents. Even with our expertise and pomposity, we find it impossible to understand the true meaning underlying some of the works in this collection and humbly request the assistance of volunteer interpretators. Opinionated, overeducated, verbose readers and others are encouraged to stop by our website and offer their narratives on the works in the "Needs Interpretation" section. Some volunteer interpretations will eventually be adopted as the official MOBA write-up, and the contributor will be named a MOBA volunteer interpretator.

— — — — —

Enough discussion! This is a collection of art that begs to be seen and enjoyed. It is clear that many of the artists suffered for their art; now it's your turn!

CHARLIE AND SHEBA
Anonymous
18" x 24", oil on canvas
Purchased at a Boston thrift store
MOBA catalog #392

No longer able to tolerate the incessant barking, Charlie the
Chipmunk uses a Band-Aid to tape Sheba the Sheepdog's mouth
shut before posing with her on the picnic table.

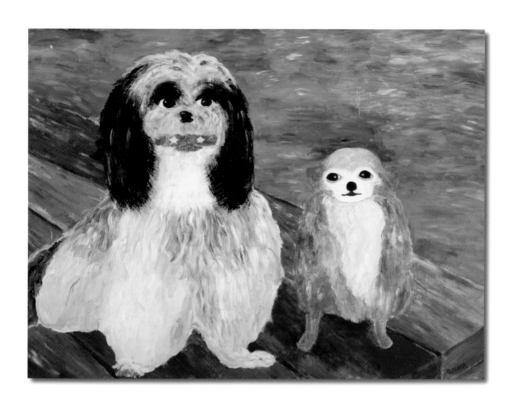

One Woman, One Artist?

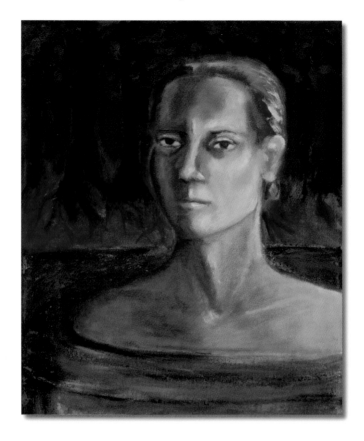

ASHEN WOMAN RISING
Anonymous
15" x 12", oil on canvas
Purchased in Jamaica Plain, Massachusetts
MOBA catalog #264

Rising from the murky depths like Nessie, this mysterious beauty from the underworld haunts the viewer with her piercing blue-eyed/brown-eyed gaze.

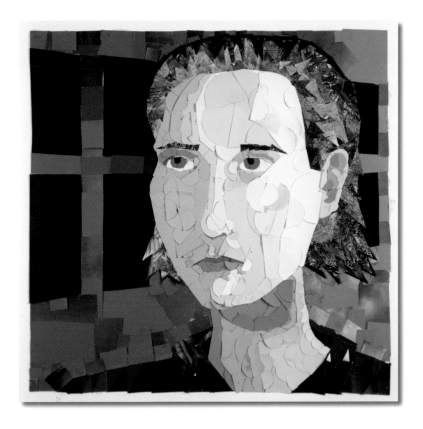

SCRAP WOMAN
Anonymous (attributed to the creator of *Ashen Woman Rising*)
15" x 15", paper and cardboard collage
Purchased in Jamaica Plain, Massachusetts
MOBA catalog #230

Attributed to the same anonymous artist who painted *Ashen Woman Rising*, *Scrap Woman* also exhibits a prominent forehead, thin eyebrows, and a penetrating stare at something behind our left shoulder—one subject, two approaches.

INVASION OF THE OFFICE ZOMBIES
Jenna Cathyla
24" x 30", oil on canvas
Left anonymously at MOBA
MOBA catalog #253

This haunting scene draws us in with subtle hints of capitalist morals. Notice the Cleveland bill gracing the crooked floor. Does it foreshadow a new denomination that drives us all to the broken jail-cell window to throw our disembodied heads to the street?

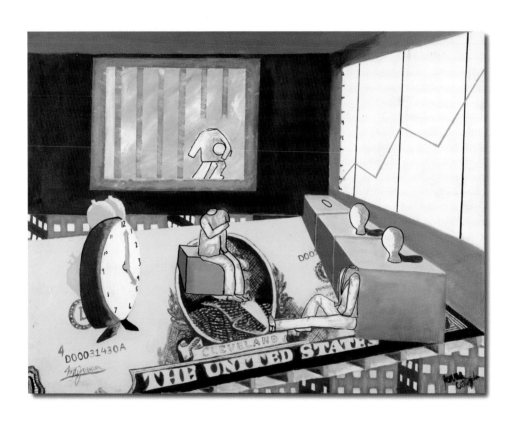

THE BETTER TO SEE YOU WITH, MY DEAR
Anonymous
20" x 16", oil on canvas
Acquired through barter with bARTer Sauce
MOBA catalog #416

Attempting to combat the pervasive sense of isolation rampant in modern society, the artist presents a bold postcubist image that compels the viewer to make direct eye contact.

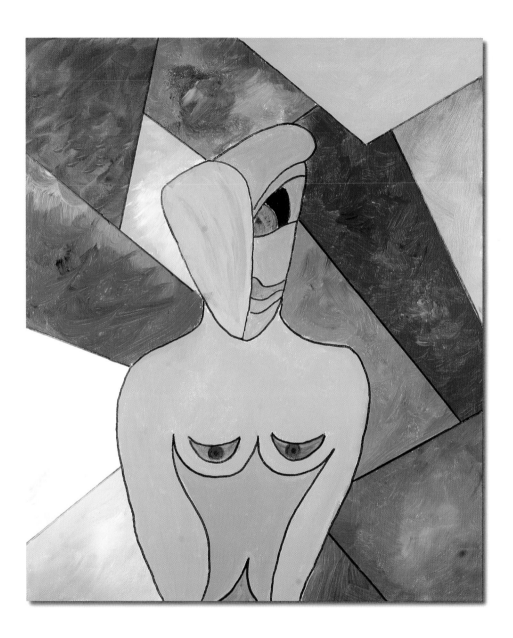

9

SADNESS
Bill Scott
26" x 18". acrylic on canvas
Left anonymously at MOBA
MOBA catalog #295

Oblivious to the serpents that slither all over him, he hangs his head and wonders what else could possibly go wrong on his tropical vacation.

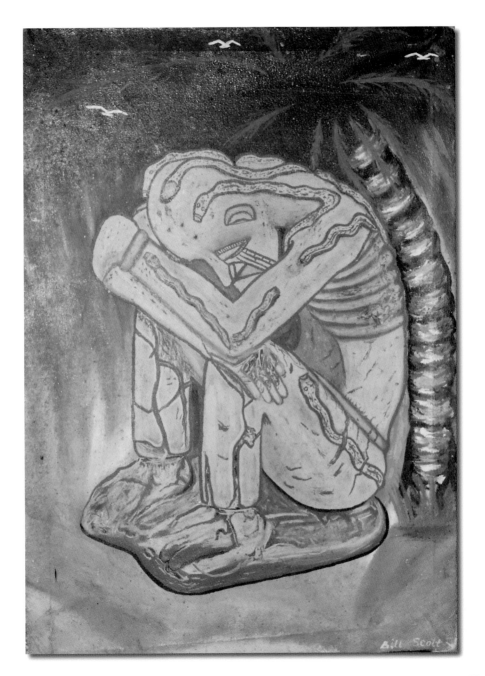

11

ANGURIA IN UN GONDOLA A VENEZIA
R. Mercer
33" x 26", oil on canvas
Donated by Mary Fadel
MOBA catalog #274

The delicate elegance of Venetian architecture is rendered care-lessly. In particular, the building at the right has pillars that don't quite line up, with one of them blocking the steps. The arches on the left vary in shape. The painter has even altered the traditional narrow Venetian gondola to make it appear more *angurial*.

"Venetians have always loved *anguria* or watermelon as a refresh-ment. Thin slices were served in the noblest parlours—in the absence of any more robust food—as several Grand Tourists observed disapprovingly. But Thomas Coryate, the irrepressible seventeenth-century visitor, was an enthusiast: 'it hath the most refridgerating vertue of all the fruites of Italy.' However he warned travellers to beware of consuming too many of other melons: 'For the sweetnesse of them is such as hath allured many men to eate so immoderately of them, that they have therewith hastened their untimely death.'"

—Michelle Lovric, from "A Piece of Cake"

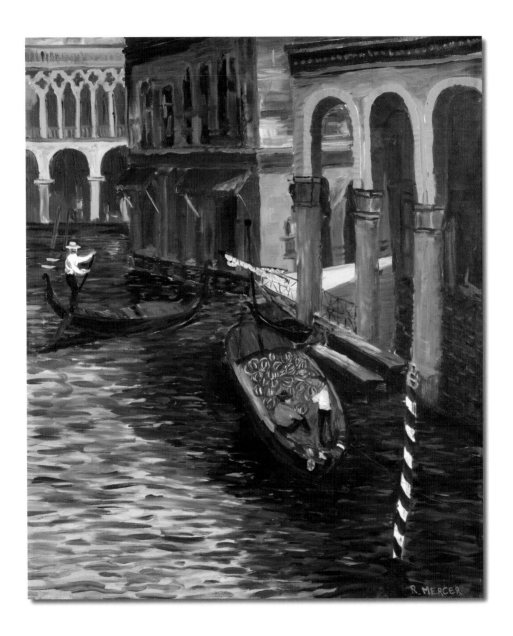

RONAN THE PUG
Erin Rothgeb
24" x 18", acrylic on canvas board
Purchased at a Boston thrift store
MOBA catalog #333

The artist's affection for her dog far outstrips her artistic skill. Paint is slapped on the canvas with random brushstrokes, creating matted, impossible fur. Done in such a hurry that the canine anatomy was not even considered, the artist still captures Ronan's playful sweetness. Or perhaps the pup has just lapped up all the spilled eggnog at a holiday party and is ready to attempt a clear tenor rendition of "Danny Boy."

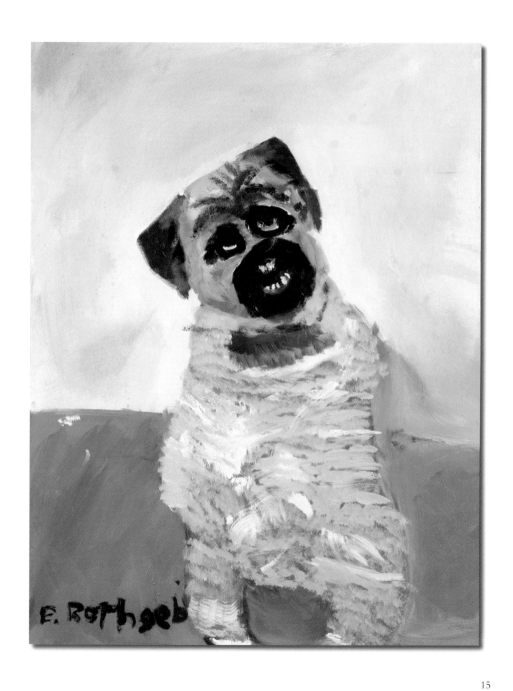

Why Should Enhancements Be Limited to Humans?

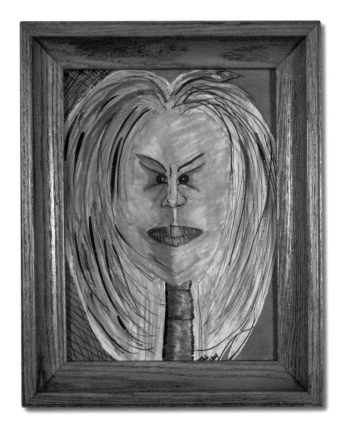

HOLLYWOOD LIPS
Anonymous
15" x 12", oil on cardboard
Purchased at a Boston thrift store
MOBA catalog #343

In Hollywood, even the palm trees have work done.

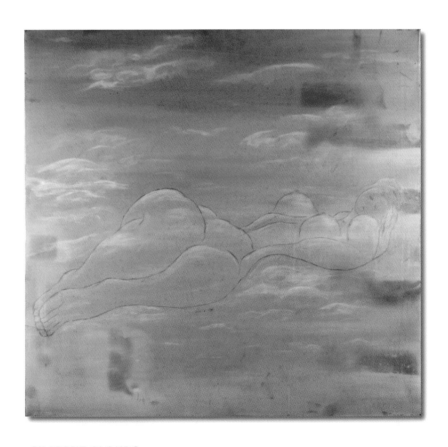

SILICONE CLOUDS
Anonymous
36" x 36", oil on canvas
Left anonymously at MOBA
MOBA catalog #419

Perky Rubenesque clouds float in a cerulean sky.

DISAPPOINTMENT
Anonymous
24" x 32". oil on canvas
Donated by Doug Shive (purchased by Kurt Beers of
 Wilmington. Delaware. at the New Castle County.
 Maryland. farmers' market)
MOBA catalog #301

Their sunburns and the empty champagne bottle help explain the man's regrettable inability to stay awake on the first night of his honeymoon. His new wife gazes blankly, wondering, "Is that all there is?"

Note: This painting is featured as CD cover art for *Subs, Shells, Spirits* by Tube Dutch, Mr. Shive's band.

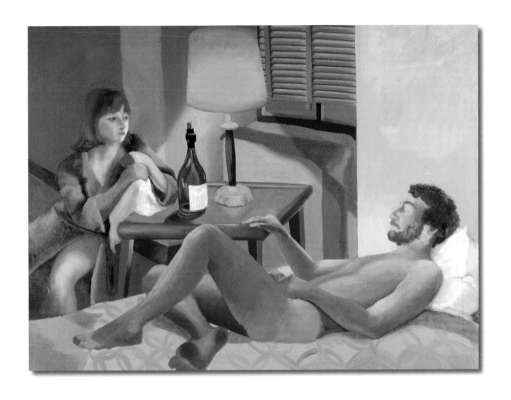

BLUE-EYED SISTAH
Anonymous
26" x 20", acrylic on canvas
Purchased at a Boston thrift store
MOBA catalog #317

A daring artist challenges our ideas about race, age, fashion, and anatomy.

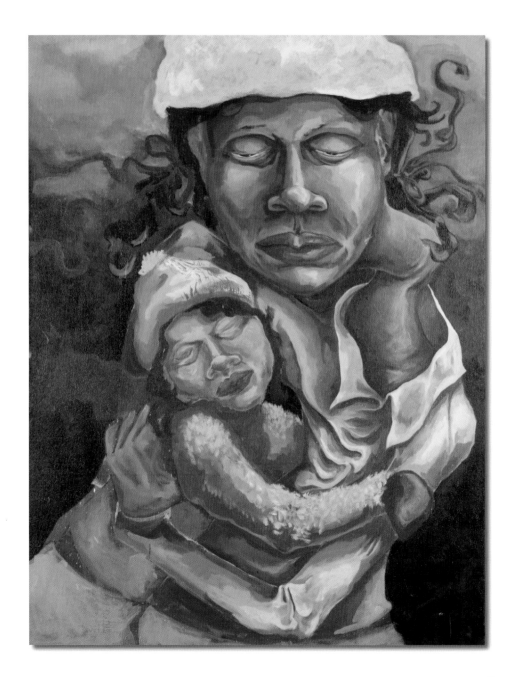

GILDED NUDE
Anonymous
18" x 12" inches, oil on canvas
Donated by Ian Michelson from New Zealand
MOBA catalog #344

The viewer is struck immediately by the youthful female subject's oversized arm.

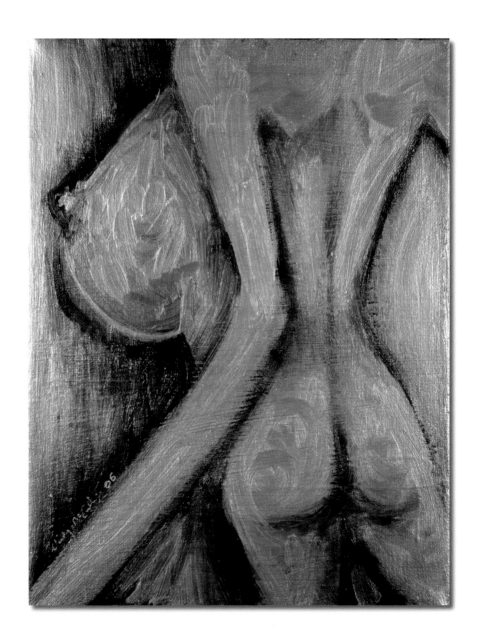

Blue Faces

The MOBA staff has long been intrigued by portraits in which the subjects are depicted with bright blue skin. The Blue Fugates of Trouble Creek are a close-knit family from the hills of eastern Kentucky who, after generations of inbreeding, include many cousins with blue skin resulting from a rare hereditary disease known as methemoglobinemia. The Tuareg people of the eastern Sahara Desert, known as the nomadic "blue men of the desert," wear indigo-dyed robes that have been known to bleed color onto their skin. Neither group, however, seems to be the subject of any of the works reproduced here.

When an artist friend exhibited a painting featuring a detailed portrayal of a blue woman (a painting Mr. Frank covets but has so far been unable to secure for the MOBA collection), the artist noted that blue paint is substantially less expensive than traditional skin tone–colored paint. Similarly, some art historians speculate that limited financial resources, in addition to his depression following the suicide of Carlos Casagemas, contributed to young Pablo Picasso's Blue Period (1901-04). We find this explanation for the plethora of bad blue art considerably more mundane than anticipated, but probably as plausible as any.

COULDA BEEN MARILYN TODAY
Roger Hanson (2003)
20" x 16". acrylic on canvas
Donated by the artist
MOBA catalog #196

A little old to have hair so blond
and lips so red. The darkness rises
and threatens to overwhelm. Are
those fading dreams around her?

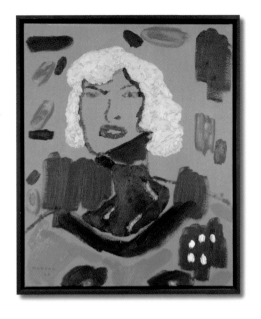

DOG BITES MAN
Vladimir Cher. Sweden
8" x 12". tempera on cardboard
Donated by the artist
MOBA catalog #360

The artist employs a no-holds-
barred approach to graphically
depict the archetypical news non-
event. Painting on the inside cover
of a *Konstnären* (*Artists*) magazine,
Cher allows the underlying red
graphic to bleed through his paint,
helping express the psychic pain
driving the animal to resort to such
violent behavior.

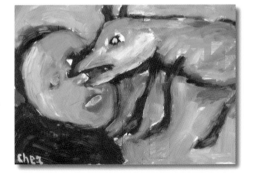

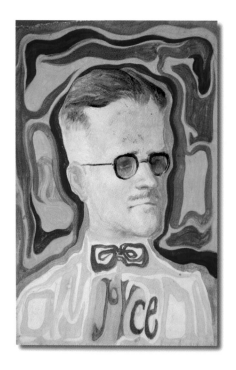

**PORTRAIT OF THE ARTIST
 AS A BLUE MAN**
Anonymous
12" x 7$^1/_2$", paint on pine
Purchased at a Boston
 thrift store
MOBA catalog #266

A famous author is depicted in a realistic, if slightly hydrocephalic, manner against a psychedelic background. His bow tie appears to be an afterthought.

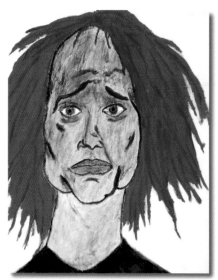

. . . TILL I WAS BLUE IN THE FACE!
Anonymous
14" x 11", acrylic on canvas
Acquired through barter
 with bARTer Sauce
MOBA catalog #322

And you thought you were having a bad day!

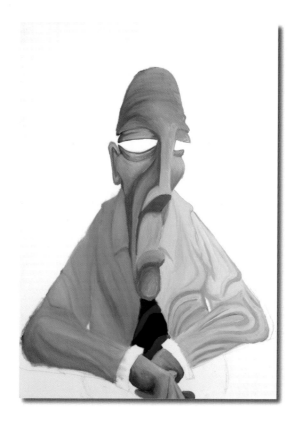

NICE BLUEISH BOY
Anonymous
4' x 3', oil on canvas
Purchased at a Brookline,
 Massachusetts, yard sale
MOBA catalog #199

This painting depicts the ancient parable in which a blueish mother gave her son a green shirt and a yellow shirt for his birthday. When he next visited his mother, the nice blueish boy wore the green shirt, only to hear his mother cry, "What's the matter, you didn't like the yellow one?"

WORRIED GUY
Anonymous
48" x 37", oil on canvas with wire, staples,
 and paper
Acquired through barter with bARTer Sauce
MOBA catalog #427

Rosalie Gale rescued this enormous painting from the trash in
Seattle, Washington. She is the proprietrix of bARTerSauce.com,
a website through which she trades unusual objects. In her
account of finding *Worried Guy*, she writes, "We drove up to
Capitol Hill where my friend Roberta Minor had seen the
painting. It was huge . . . and scary. He has metal wire hair and
fingernails and staple eyebrows. . . . I decided that since the guy
looks so worried, I would write down all the stuff that I worry
about all the time and stick them to his wire hair. Then I'd just
let him worry about them."

 Among the worries she let him assume were:
 "Large bodies of water"
 "Having too much stuff"
 "$"
 "Staying home from work"
 "Spiders"
 Everyone at MOBA hopes
Ms. Gale is enjoying her carefree
existence and has not found
more things about which to
worry.

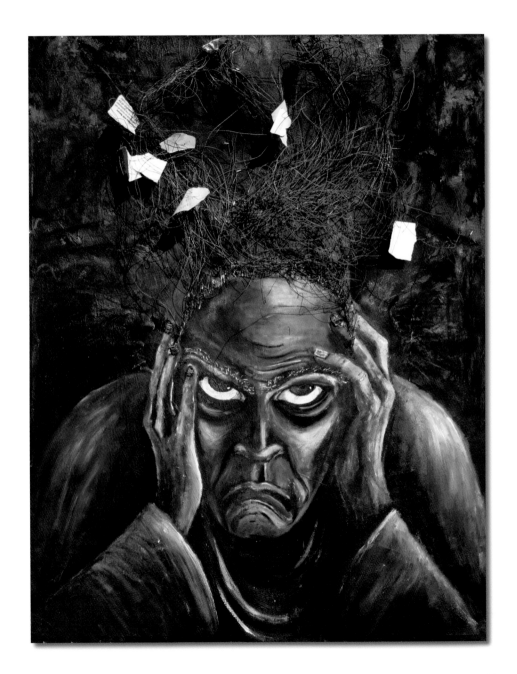

YIKES
M. Starbuck
23" x 12", tissue-paper collage
Purchased at a Boston thrift store
MOBA catalog #406

Stick-straight arms and muscled legs; dark body and light face; realistic, stylized feet and star-shaped hands—this energetic portrait is full of contradictions. Is she a suburban club kid, wearing the latest, briefest skirt and top with bangle bracelets?

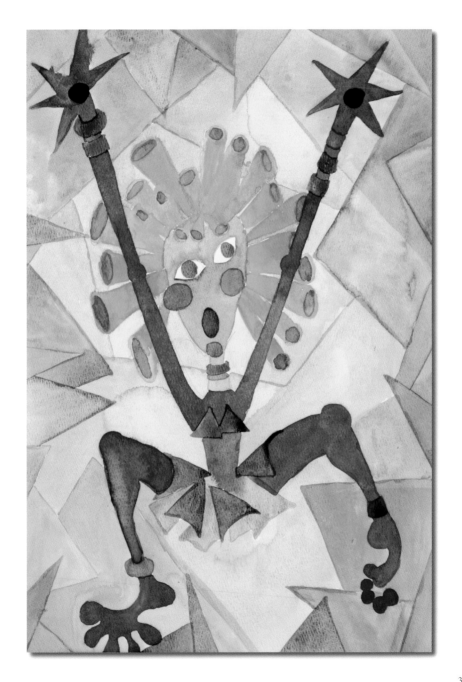

PROSTHETIC CLAW
William F. Murphy
12" x 20", oil on canvas
Donated by Karen McHugh (purchased at a
 thrift store in Winston-Salem, North Carolina)
MOBA catalog #426

Inspired by the film *Jurassic Park*, many have speculated about the possibility of using traces of fossilized dinosaur DNA to produce a living *Tyrannosaurus rex*. Advances in cell-engineering techniques have led others to speculate about the possibility of using stem cells to grow human tissue. One scientist, Dr. Jose Cibelli, went so far as to secretly clone his own DNA inside a cow egg.

Prosthetic Claw portrays the unexpected results in this ethical boundary–stretching field of interspecies cloning. The central figure's immaculate white shoe contrasts with the grotesquely poor grooming of the hand, which is depicted in a universally understood gesture. The artist seems to be saying that these experiments will result in a giant "goose egg." The heavy-handed image is marred by a clumsily executed background of straight-from-the-tube oil paint colors that have become all too familiar to the MOBA curatorial staff.

THE ACTOR
William E. Judge (1974)
24" diameter, oil on canvas
Left anonymously at MOBA
MOBA catalog #246

Highlighted hair (or very complex lighting) draws attention away from the actor's receding hairline and piercing white eyes. His dejected gaze seems to reflect the realization that he is no longer suited to the leading man roles to which he once aspired.

35

Apocalyptic Post-Global Warming Images

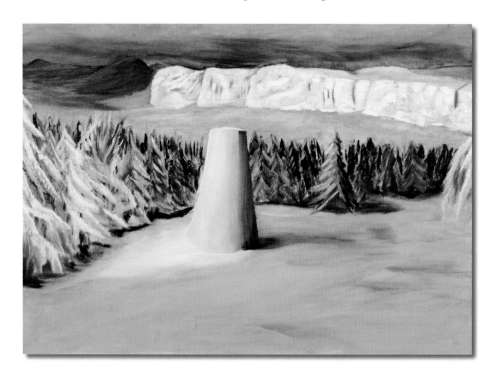

WINTER MONOLITH
KDR (August 1997)
18" x 24", oil on canvas
Purchased at a Boston thrift store
MOBA catalog #284

A strange monolith casts a glowing shadow on the tundra in this icy landscape. Even the trees shrink from the symbolic industrial structure in their midst. What else will be revealed as global warming causes the glacier to recede farther?

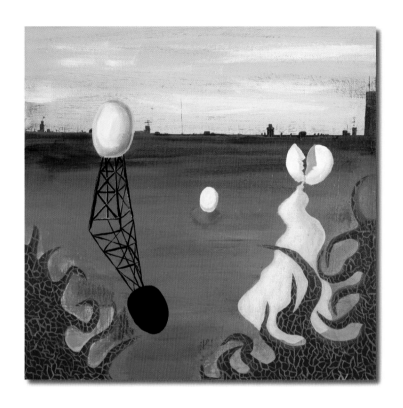

DRILLING FOR EGGS
William F. Murphy
30" x 30", oil on canvas
Donated by Karen McHugh (purchased at a
 thrift store in Winston-Salem, North Carolina)
MOBA catalog #428

Green alligator flames dominate the foreground and a bright
pink sky provides the backdrop for this disquieting depiction of
a color-altered future in which eggs, a renewable resource, have
replaced traditional hydrocarbon fuels. The artist is saying, in no
uncertain terms, that unless we learn to conserve our priceless
resources, the yolk will be on us.

THE SCIENTIST
Anonymous
28" x 36", mixed media
Left anonymously at MOBA
MOBA catalog #382

Latex gloves and bodily fluids add color to this piece, which depicts a laboratory experiment gone horribly awry.

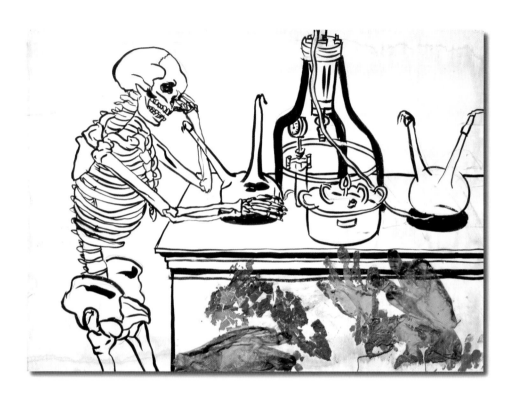

AIM 2
Lloyd Graham (Australia, 2006)
24" x 18", oil on canvas
Donated by the artist
MOBA catalog #372

"[This is m]y partner, Lyn, losing the battle with the middle objective of her research grant proposal (something to do with cross-talk between insulin-like growth factor binding proteins and retinoid-X receptor heterodimerization, since you asked)."

 —Text by the artist

Keys

As found objects to incorporate into art, keys are full of meaning—versatile, ubiquitous, inexpensive, and shiny.

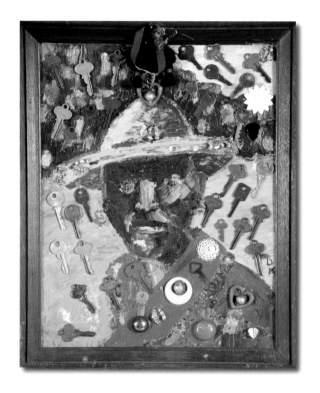

KEY MAN
Anonymous
18" x 14", oil, keys, and found objects on canvas board
Left anonymously at MOBA
MOBA catalog # 256

A resident of Key West, Florida.

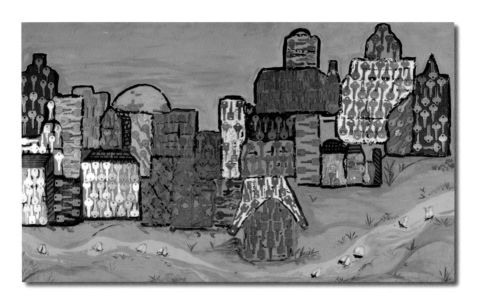

KEYS TO THE CITY
Anonymous
30" x 50", paint, plaster, keys, and cloth on plywood
Purchased at a Boston thrift store
MOBA catalog #283

Once a sleepy backwater, Key West is threatened with overdevelopment since becoming a popular destination for sailing enthusiasts.

THE WEIGHT LIFTER
Tom W.
19" high, fabric strips, plaster of Paris, and paint
Salvaged from a curbside trash pile in Boston
MOBA catalog #155

The artist celebrates the winning can-do spirit of athletes who, eschewing the advice of coaches, trainers, and chiropractors, accomplish tremendous physical feats using unbelievably poor technique.

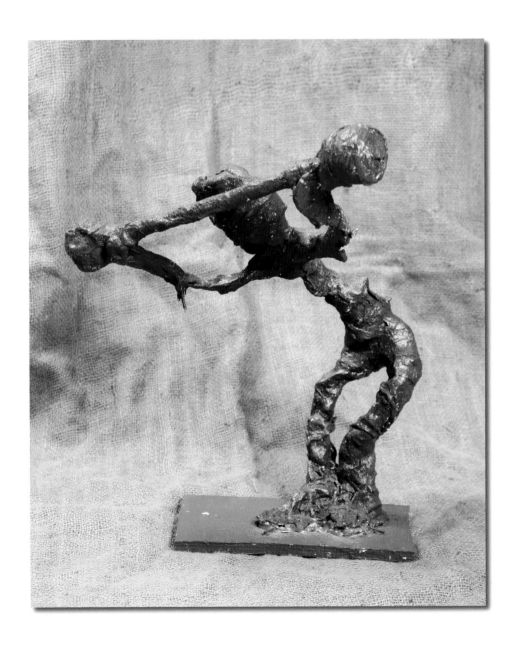

PLAYING WILLIAM TELL
Anonymous
20" x 20", oil on canvas
Left anonymously at MOBA
MOBA catalog #356

This is a chilling portrayal of an incident involving Beat writer William S. Burroughs and his common-law wife, Joan Vollmer. On September 7, 1951, Burroughs and Vollmer were drunk at a party in Mexico City when he told her, "It's time for our William Tell act." Joan placed a glass of water on her head. Bill took out his gun, aimed, and accidentally, fatally, shot her in the head.

This portrayal of the incident is set against black, as befits a Beat poet. Joan's anguished expression and pale visage eclipse her cheerful polka dots and foretell the tragic outcome of the stunt. But she is incidental to him, in whose slightly feminine face we see the glazed expression of a drug-addicted, heavy-drinking misanthrope with a heart-shaped ear. Burroughs went on to write *Naked Lunch, Junkie, The Soft Machine*, and many other books not for the fainthearted.

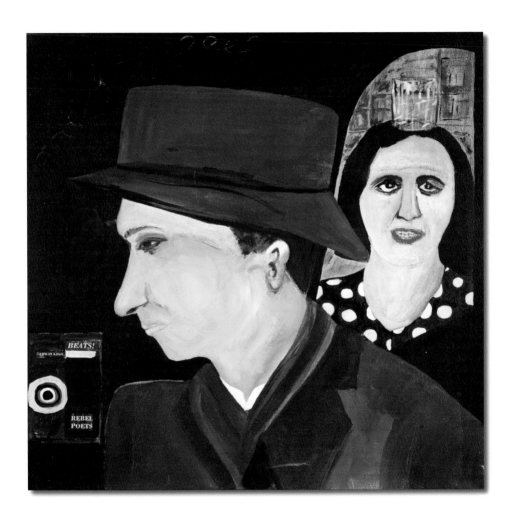

QUEEN OF THE CHOCOLATE CHIP
Christian
22" x 15", watercolor on paper
Acquired from a Hyde Park, Massachusetts, yard sale
MOBA catalog #180

The piece comments on the incongruity of royalism at the close of the second millennium. The formality of the pose contrasts with the laissez-faire attitude of Her Majesty, caught midchew and sporting a jaunty beret, which she clearly prefers to her emerald-encrusted crown. We are, in fact, amused.

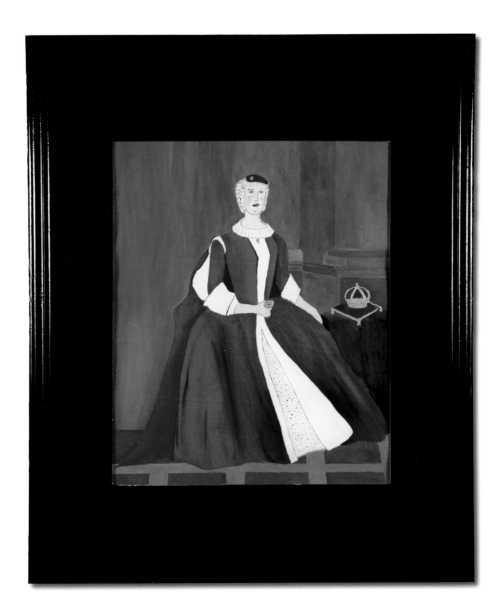

SENSITIVE
Anonymous
20" x 16", marker on cloth with paper
Purchased at a Boston thrift store
MOBA catalog #414

There may have been an argument that ended with the artist yelling, "Sensitive? You want sensitive? I'll show you sensitive." The outraged splashes of dark color, the scribbled words, and even the angry stick figures are callous, thick-skinned, and indurate— no matter how insistent the word "sensitive" becomes.

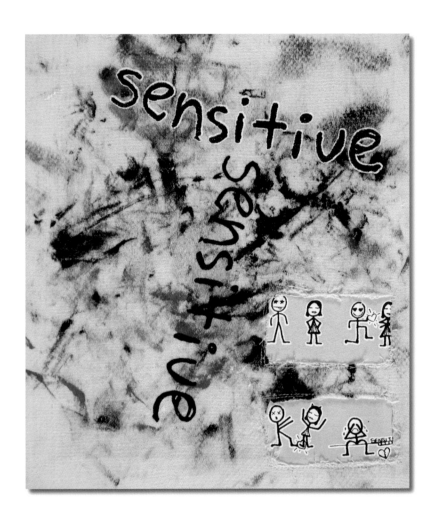

BONE-JUGGLING DOG IN A HULA SKIRT
Mari Newman
40" x 16". tempera and acrylic on canvas
Donated by the artist
MOBA catalog #214

This is a delightful example of labor-intensive pointlessism. The MOBA interpretative staff scratched our heads in wonder as we tried to imagine what would possess an artist to portray a dog juggling bones while wearing a hula skirt. When the curator-in-chief asked artist Mari Newman directly, she responded, "Having no money while taking art classes in college, I helped myself to used canvases left behind by other students. This canvas was long and narrow. I couldn't think of an idea for a ragged canvas that shape until I saw a cartoon of a wiener dog standing upright. I painted a dog on the used canvas but was not happy with it. After seeing hula girls in a magazine, I put a hula skirt on the dog on a lark. After I saw a jar of colorful dog bones in a pet store, I added them to my painting. I continued to work on the picture, but almost threw it out until I heard of MOBA. After many years of slashing rejected work, now I wish I had saved them all for you."

Mari Newman is a prolific artist living in Minneapolis, Minnesota. Everyone at MOBA is grateful that she understands that *Bone-Juggling Dog in a Hula Skirt*, and many of her other works (including paintings, drawings, and three-dimensional collages featuring Barbie dolls, hot water bottles, and found objects) belong in the MOBA permanent collection. Ms. Newman's "outsider art" is represented in many other museums, including the Pensacola Museum of Art, the Tampa Museum of Art, the New Orleans Museum of Art, and the Columbus Museum of Art (Ohio).

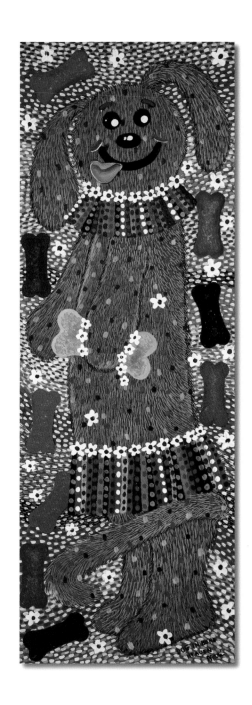

53

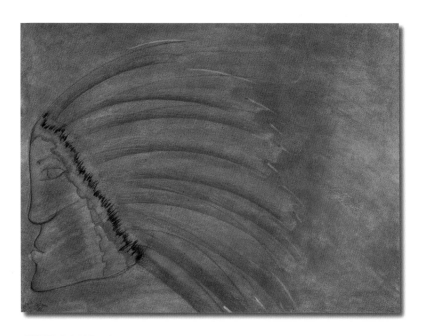

CHIEF PONTIAC
Wynnette Scheffield
12" x 16", pastel on paper
Discovered in a folder of pastels donated to MOBA
MOBA catalog #320

Here is evidence of a technical struggle to distinguish the face from the background. The artist's bold solution is to grab a pencil and create sure, strong lines to define the headdress. The resulting portrait bears an uncanny resemblance to Chief Pontiac, as depicted in a 1950 Pontiac Chieftain hood ornament (at right).

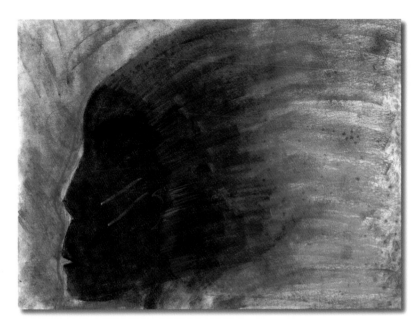

MRS. PONTIAC
Attributed to Wynnette Scheffield
12" x 16", pastel on paper
Discovered in a folder of pastels donated to MOBA
MOBA catalog #319

This is the chief's lovely Nubian wife.

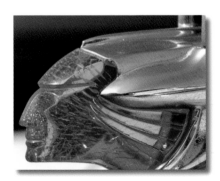

CREW-CUT DREAMS
Leonardo (1997)
10" x 9", oil on art board
Purchased at a Boston thrift store
MOBA catalog #300

A man with short hair is depicted among seals, snakes, and other creatures that share his bright red facial features. At first glance, we expect him to be uncomfortable or threatened. But these creatures smile and cuddle. There are no nightmares here—just the happy dreams of friendly forces that make life more pleasant.

MANA LISA
Andrea Schmidt (Vancouver, Canada)
16" x 12", oil on canvas
Donated by the artist
MOBA catalog #370

This is a cross-gendered interpretation of the Leonardo da Vinci classic. *Mana Lisa*'s nose is critical to the composition, offsetting the dialogue between the foreground and the profoundly varnished background. Taking a cue from the best-selling book *The Da Vinci Code*, anagrams offered by the work's title can perhaps contribute to a deeper understanding of the work:

MAN ALIAS
A SAIL MAN
AS ANIMAL
AM A SNAIL
MAIL NASA
I AM NASAL

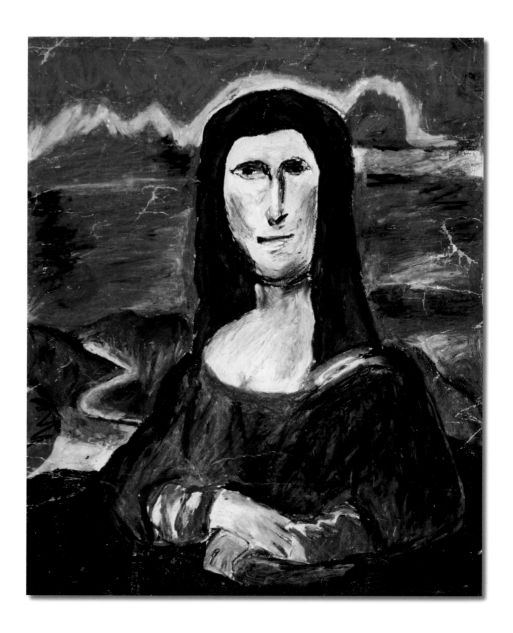

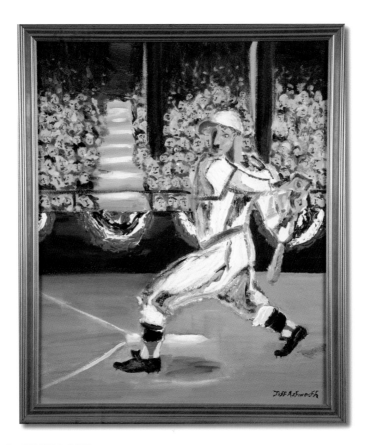

K. C. AT THE BAT
Jeff Ashworth
20" x 16". acrylic on canvas
Left anonymously at MOBA
MOBA catalog #290

The great American pastime meets the late nineteenth-century innovative style of James Ensor. Asymmetrical limbs and a flexible bat help this half-black, half-white all-star develop tremendous torque at the plate. The spectators silently gaze, transfixed.
— Text by MOBA Volunteer Interpretator Stephen Haske

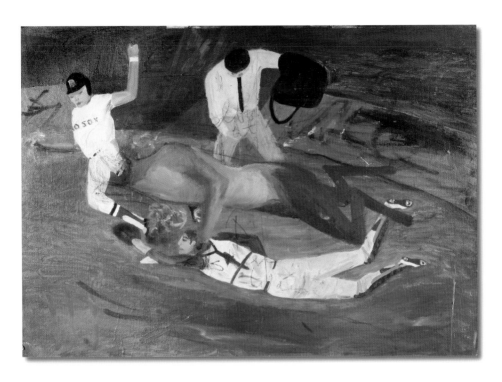

SAFE AT HOME
Anonymous
24" x 32", oil on canvas
Left anonymously at MOBA
MOBA catalog #292

The old-town team runner successfully avoids the catcher's tag at the plate, only to be swallowed by a mysterious fan. We are left to wonder why the Red Sox player decided to return home from first base.

AFTER THE STORM
Brother Stephen Lendvay (CSSR, 1972)
16" x 20", acrylic on canvas board
Purchased at a Boston thrift store
MOBA catalog #328

The perfectly coiffed trees look none the worse for wear as mild
weather returns to the valley. Clearly, Brother Stephen's inspiration
was the work below, from Eugene Frandzen's book *How to Paint
with Casein, Watercolors, Tempera, Gouache, and Oils* (Walter T. Foster,
1960). The tree detail from another work in Frandzen's book
confirms that Brother Stephen was, indeed, one of Frandzen's
many art disciples.

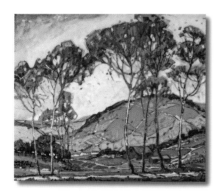

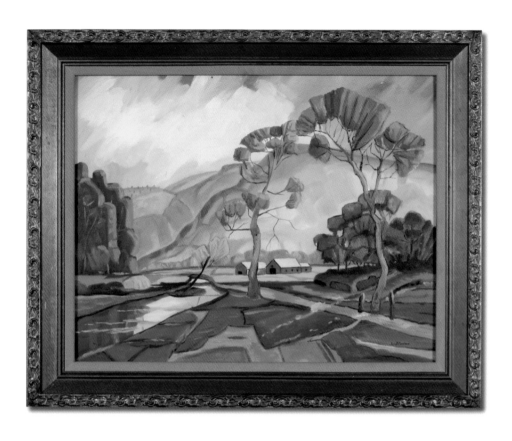

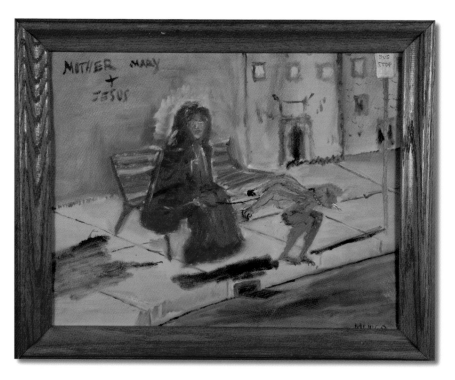

MOTHER MARY + JESUS
Mungo
13" x 16", oil on canvas
Purchased at a Rowley, Massachusetts, flea market
MOBA catalog #396

This is a daring twist on a favorite subject. There is a carelessness in the slapdash technique and the minimalist background, and in labeling the piece *Mother Mary + Jesus*. But Mungo's piety and thoughtfulness show through, portraying Christianity's central figures in a modern urban setting. The Virgin Mary, though in untraditional red garb, has a traditional halo. She waits serenely for a bus with her young son, who is inexplicably depicted as a hyperactive simian with a blaze orange Mohawk.

STUDY FOR MOTHER MARY + JESUS
Attributed to Mungo
9" x 12", oil on canvas
Salvaged from a curbside trash pile in Boston
MOBA catalog #395

In a reversal of the usual process, this study is larger, more detailed, and more carefully rendered than the figure in the final work. The MOBA staff is happy that these works have been reunited. They were acquired twenty-seven months and twenty-five miles apart.

ELIÁN GONZÁLEZ'S GRANDMOTHERS
Gisela Keller (1973)
18" x 24", oil on canvas
On loan from a private collection
MOBA catalog #193

Lush tropical foliage dwarfs the tiny *abuelas*, and brilliant colors demand the viewer's attention. Painting almost thirty years before Elián González, a tiny Cuban refugee, was plucked by the United States Coast Guard from the ocean near Florida, this visionary artist depicted the boy-hero's grandmothers' return visit from Miami to their native Cuba, where the tropical plants are *muy grande*.

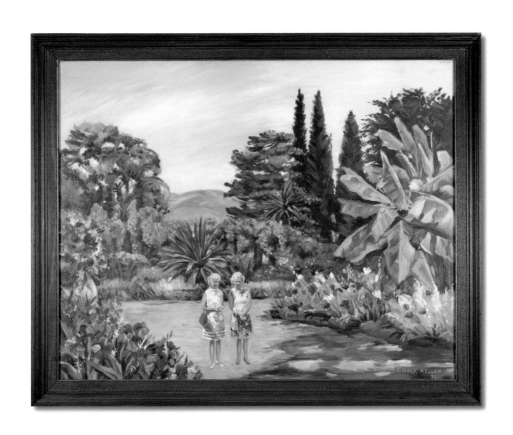

GINA'S DEMONS
Gina
28" x 20". oil on canvas
Donated by M. J. Maccardini and Erin Howe
(purchased at a flea market near Northampton.
Massachusetts)
MOBA catalog #262

Frightening nonkosher demons haunt this blonde, blue-eyed beauty in a see-through blouse. Her world is cracking apart at the edges, but her careful hairdo and makeup show us that she knows it's important to keep up appearances.

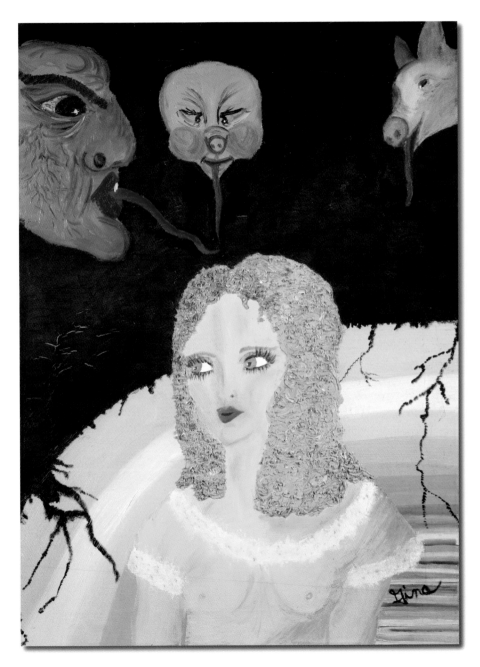

Extremes of Perspective

SEE BATTLE
Viv Joynt
24" x 18", acrylic on canvas
Donated by the artist at a MOBA event at
 the Saw Gallery in Ottawa, Canada
MOBA catalog #394

We don't need binoculars to predict which dreadnought will be victorious in this nautical fray. Some viewers assume that the small object just beneath the ship on the right is a lifeboat carrying sailors lucky enough to escape the inferno. The MOBA curatorial staff has determined that it is, in fact, a ladybug on the window just in front of the binoculars.

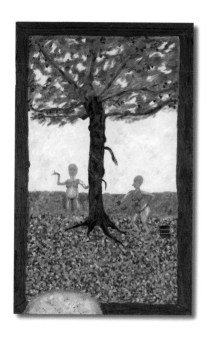

ALIEN ADAM & EVE
Katherine Somerville Howorth Bouman
40" x 18". oil on canvas
Donated by the artist
MOBA catalog #248

"I'm an atheist, so I depicted Adam and Eve as purple aliens. I put them in a landscaped garden, a comment on today's suburban paradise and the Garden of Eden. The viewer looks out a kitchen window to see Adam and Eve picking apples in the manicured backyard, with an apple pie cooling on the window ledge. Did the aliens bake the pie? Did the viewer? What does it mean to bake and eat a pie made from a symbol of knowledge?"

 —Text by the artist

"Mmm . . . I love apple pie."

 —Response from MOBA curator-in-chief

TO LIFE
Mark Gewiss (August, 1993, Newport, Pennsylvania)
12" x 9¹/₂", paint on pine
Purchased at a Boston thrift store
MOBA catalog #265

Inspired by Edvard Munch, the man with a SpongeBob
SquarePants body throws up his hands and screams "*L'chaim!*"

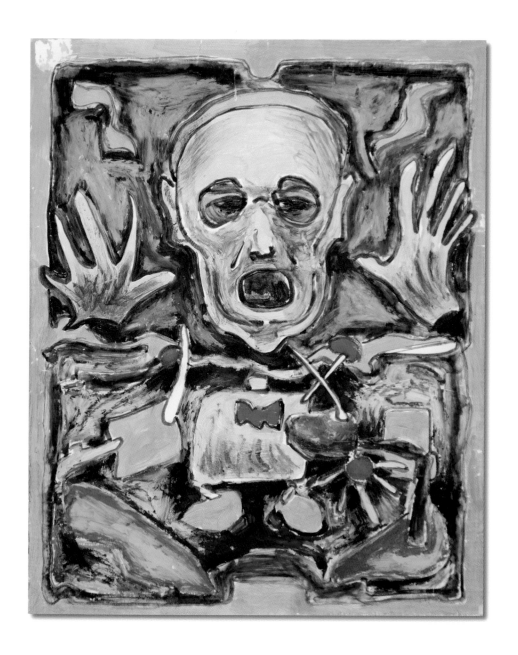

THE PICNIC
Anonymous
30" x 22". oil on canvas
Donated by Mark Onishuk
 (purchased at a Boston thrift store)
MOBA catalog #353

Aware that interoffice dating is frowned upon by upper manage-
ment, the young lovers decide to take an extended lunch break on
a private island where they will not be seen. We can see that the
world smiles on these lovers.

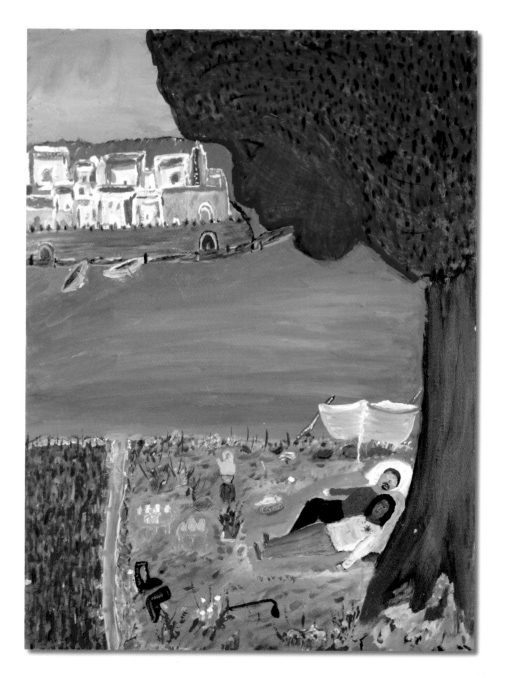

Despair and Hope

With mirror images and similar color palettes, one conveys despair, the other youthful hope.

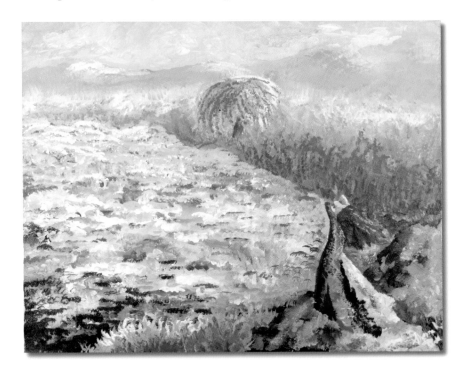

ANSWER ME
Shauna Peck
17" x 22", acrylic on canvas
Donated by the artist's mother
MOBA catalog #006

Mauve madness transcends the trite with agony too painful to behold. Passionate purple defines the despairing woman, the roiling sea, and the angry sky.

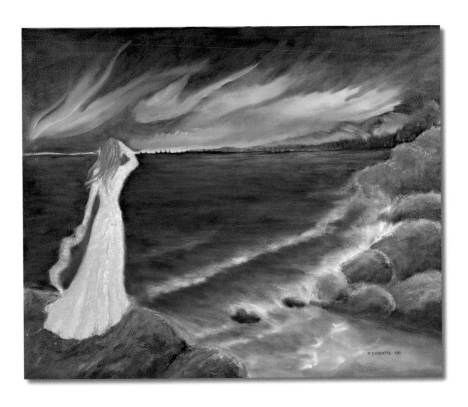

AURORA BOREALIS
M. Choquette (1931)
18" x 22", oil on canvas
Donated by Mary Fadel
MOBA catalog #313

Blinded by the northern lights, the beautiful maiden wanders the coast nightly hoping for a glimpse of her lover's ship, which she fears is lost at sea. She doesn't realize he joined the navy because he prefers the company of his fellow sailors. The white dress, white waves, and white lights give this piece a lightness that conveys eternal hope, no matter what.

SUPERSTAR
Name illegible
13" x 11". paint on wood
Donated by Louis Frank and Jen Campbell
MOBA catalog #279

Many faces are depicted in a crazy-quilt jumble. The artist's use of common pine and monochromatic hues indicates an underlying democratic belief that everyone is a star.

DISSENT FROM THE PEDESTAL
Robert MacLeod
30" x 36". oil on canvas
Left anonymously at MOBA
MOBA catalog #311

Infuriated and distraught about the state of the world, the iconic Lady of the Harbor has come down from her traditional perch, bemoaning the fact that, despite global warming, her day in the sun seems to have passed.

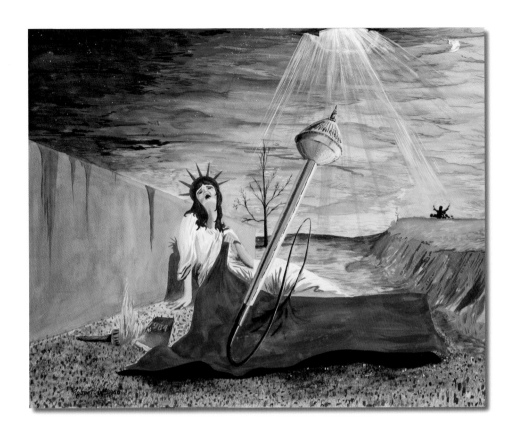

LONG ARM OF THE LAW
Farleigh Goss
2' x 4', oil on canvas
Purchased at a Boston thrift store
MOBA catalog #263

Bare-breasted and blind, Lady Justice is portrayed here in a variation on a traditional subject. Rather than cover her face with a blindfold, the artist depicted her with no eyes. While she is often seen holding the scales of justice, a sword, and/or a book, she is in this painting juggling a ball of dreaded kryptonite in her ample hand at the end of the long arm of the law.

LITTLE LADY
Anonymous (attributed to
Farleigh Goss)
5" x 7", acrylic on canvas
Purchased at a Boston
thrift store
MOBA catalog # 411

This interesting little painting may be a study for *Long Arm of the Law*. In the final version, the artist reinforced the positive imagery by turning the subject's hand and face upward.

Beaches

Tropical beaches are irresistible to artists.

ANDAMAN BEACH (PHUKET, THAILAND)
Althea Clark, 2005
20" x 24", acrylic on canvas
Purchased at a Phuket, Thailand, yard sale
Not cataloged in the MOBA collection

This is a fine example of what we refer to as tourist art. We include it here to illustrate the genre.

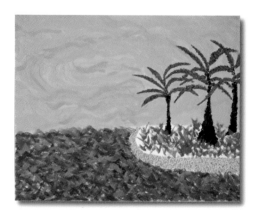

BEACH AT SUNSET
Anonymous
16" x 20", acrylic on canvas
Purchased at a Boston thrift store
MOBA catalog #385

This is a nonprofessional version of a scene similar to *Andaman Beach.* In this treatment the water is choppier, the sky is more colorful, the palm trees are spikier, and the island is rounder.

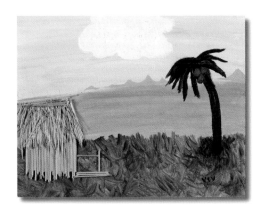

CHICKEE AND PALM TREE
Viv Joynt
16" x 20", acrylic and straw on canvas
Donated by the artist
MOBA catalog #393

Viv combined media and techniques in this tropical scene. The dense finger-painted grass threatens to envelop the tiki hut and the palm tree, which is heavy with coconuts. Fluffy clouds float above, and the sea virtually shimmers. But where are the people? Who built this? Have they abandoned this paradise for the lure of the mysterious mountains across the sea?

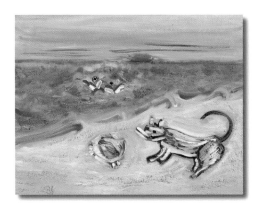

ON THE SHORE AT SUNSET
Anonymous
16" x 20", oil on art board
Purchased at a Boston thrift store
MOBA catalog #278

Two bathers' frantic calls for help go unnoticed as another life-and-death drama unfolds between the identically colored crab and cat. The artist added real sand to the paint to give the beach a realistic texture and to indicate that the surf was dangerously rough.

MY LEFT FOOT
Sooz (1991)
30" x 36", oil on canvas
Left anonymously at MOBA
MOBA catalog #271

The feet, mismatched in color and shape, are the well rendered work of a skilled artist. Sooz succeeds in getting us to think about the nature of feet and to face our discomfort with asymmetry in any human form. The floor tiles raise questions about our need for orderly surroundings. Accuracy and perspective are just too difficult and boring, and the tiles are in the background, anyway.

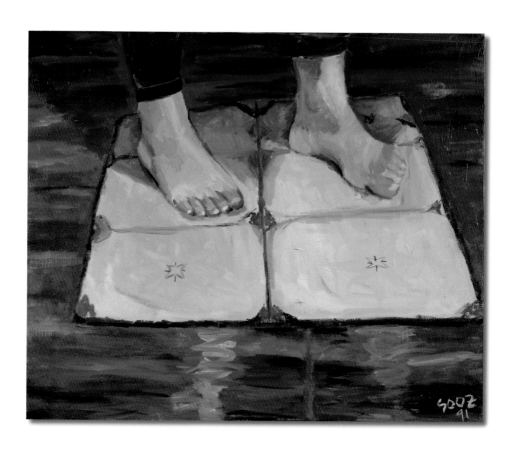

INAUGURATION DAY 1961
Mark Finley
36" x 30", acrylic on canvas
Donated by Joe Donovan
MOBA catalog #338

The president's father beamed with pride on that cold, windy day when his son, looking eerily like the future King of Pop, ignored the snow piling up on his face and suggested we ask not what our country could do for us, but what we could do for our country.

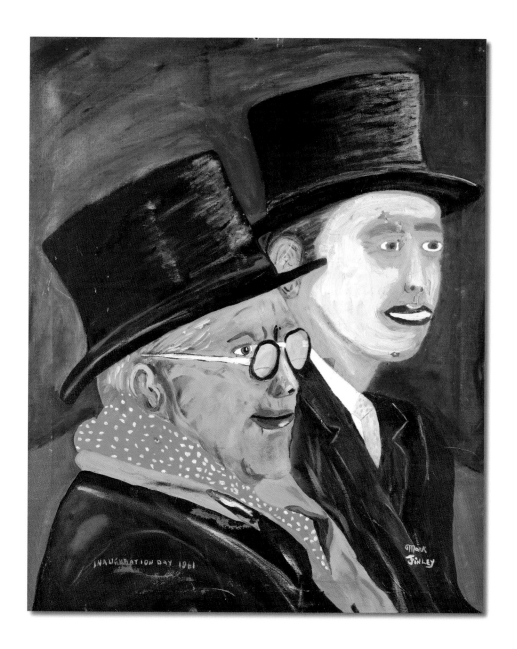

89

HE WAS A FRIEND OF MINE
Jack Owen
24" x 18", watercolor on paper
Purchased at a Boston thrift store
MOBA catalog #368

The artist is a skilled watercolorist, as is evident by his knowledge-able use of negative space to create the ghostly husky. The sparkle in the eyes of the see-through cat brings a discordant, evil glint to an otherwise soft and peaceful scene. "Who else thinks it's a good idea to eat from my bowl?"

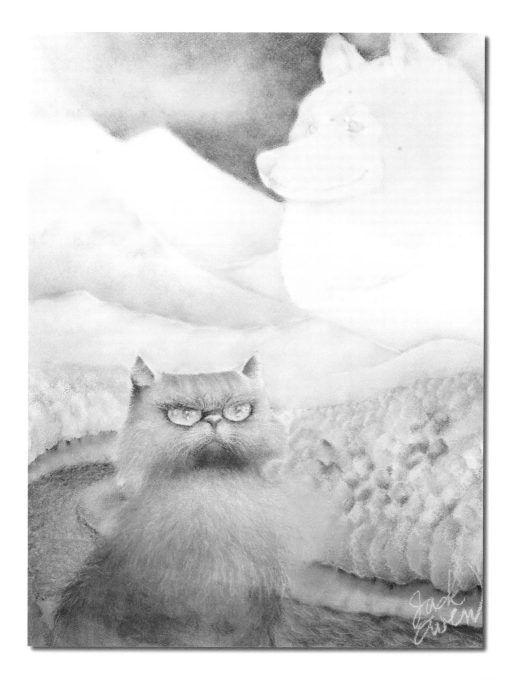

TREES. WHEELBARROW. AND BLUEBIRDS
Anonymous
20" x 16". acrylic on canvas board
Purchased at a Boston thrift store
MOBA catalog #381

Three trees are balanced precariously in a wheelbarrow, but the artist's straightforward optimism and good cheer assure us that the future is bright. Leaf colors, though unlikely, are intense; bluebirds circle through the trees; and the loaded wheelbarrow sits lightly on the grass. The artist's confident strokes convince us that all is well.

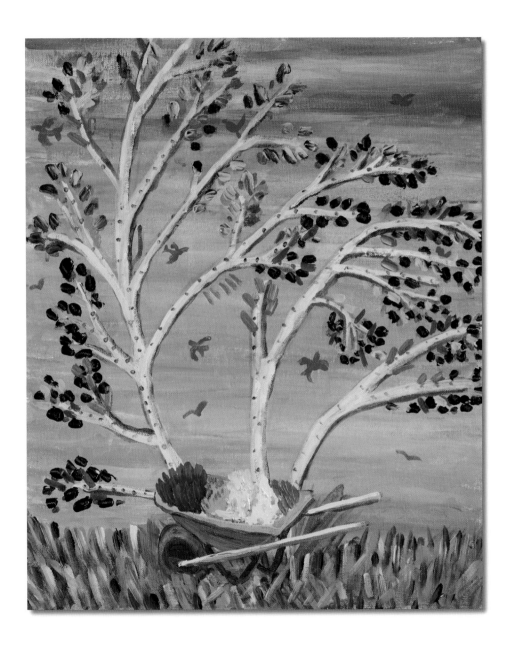

ANNIE'S DOWNSTAIRS SECRET
Professor Kendall Moore
 (Department of Journalism, University of Rhode Island)
18" x 14", acrylic on canvas panel
Donated by Doug Shive
MOBA catalog #335

Impressed by how well they worked on her pets' and her own teeth, Annie used Crest Whitestrips to brighten her toenails.

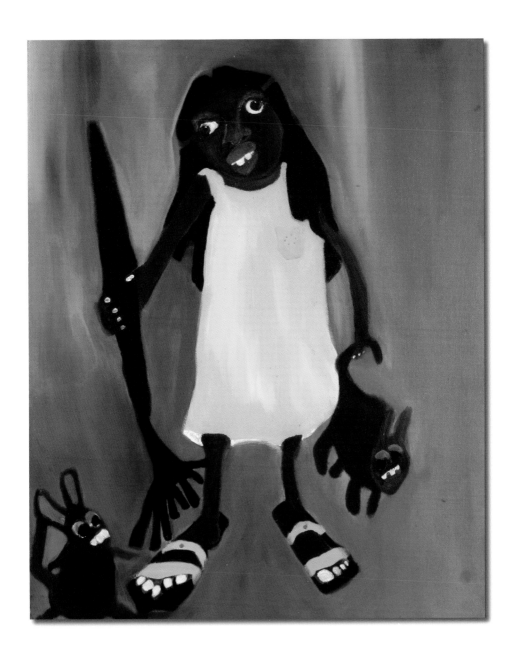

SAD BABY
Anonymous
20" x 16". oil on canvas
Purchased at a Boston thrift store
MOBA catalog #259

Lost puppy? No one to play with? Nothing on TV? What sad fate has befallen this young beauty with the big red bow? Only the bright chandelier hanging curiously close to the wall breaks the monotony of the limited color palette that seems to symbolize the young girl's ennui. Her life seems so empty that she must even conjure an imaginary shelf on which to lean.

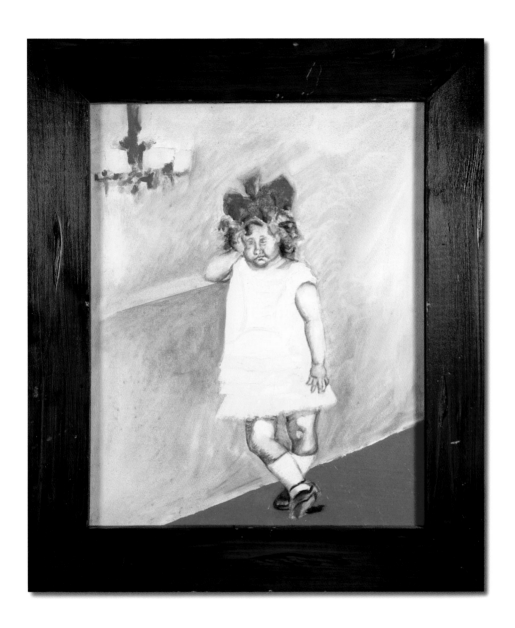

LULLI, FOWL, AND GRAVESTONE
Michael Frank (August 1971, Copenhagen, Denmark)
8$^1/_2$" x 11", watercolor on paper
Donated by the artist
MOBA catalog #347

This work was presented to Lulli in Copenhagen and subsequently returned to the artist in New York by mail soon after. The significance of Lulli and the objects portrayed was important to the artist at the time but was, unfortunately, erased from the artist's memory long ago.

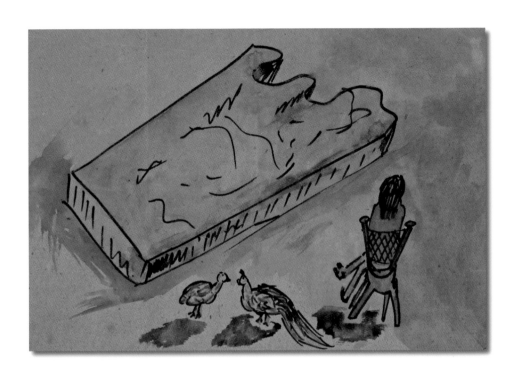

THE WATERFALL
Anonymous
20" x 16". oil on canvas
Purchased at a flea market in Buffalo, New York
MOBA catalog #346

Snowcapped peaks tower over this summer meadow featuring evergreens, wildflowers, and a waterfall of mysterious origin.

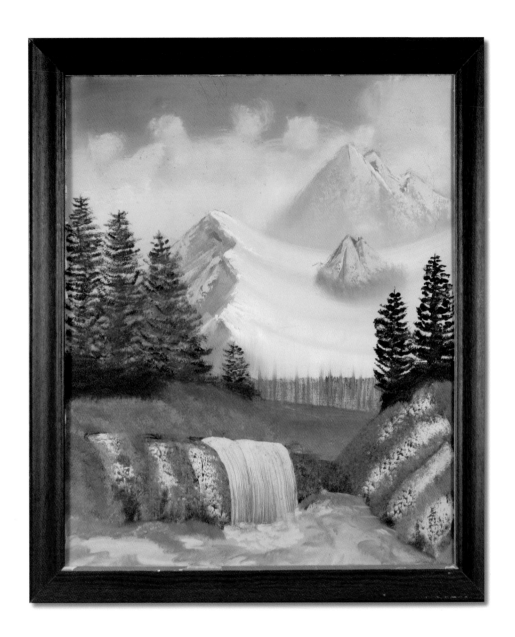

SPEWING RUBIK'S CUBES
K. Koch
18" x 24", oil on canvas
Purchased at a Boston thrift store
MOBA catalog #380

This image of the classic 1980s toys emanating from a jester gargoyle's mouth can only be described as puzzling.

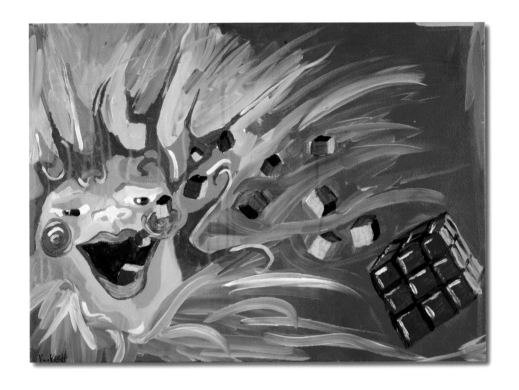

RETCH LIKE AN EGYPTIAN
Anonymous
12" x 16", pastel on paper
Discovered in a folder of pastels donated to MOBA
MOBA catalog #321

This is a disturbing image of an Egyptian doubled over in pain, throwing up colorfully. The X-ray box clearly shows the source of his discomfort, and the black smoke from the pyramid indicates that a new pharaoh has not yet been chosen. More study is needed to determine the meaning of the squiggly lines above and behind him.

HEATHER COME HITHER
Bianka
30" x 24". oil on canvas
Salvaged from a curbside trash pile in Boston
MOBA catalog #280

Larger than life, she purrs with her big bedroom eyes open wide in anticipation, "Hello, boys." Bianka knew, the more hair the better.

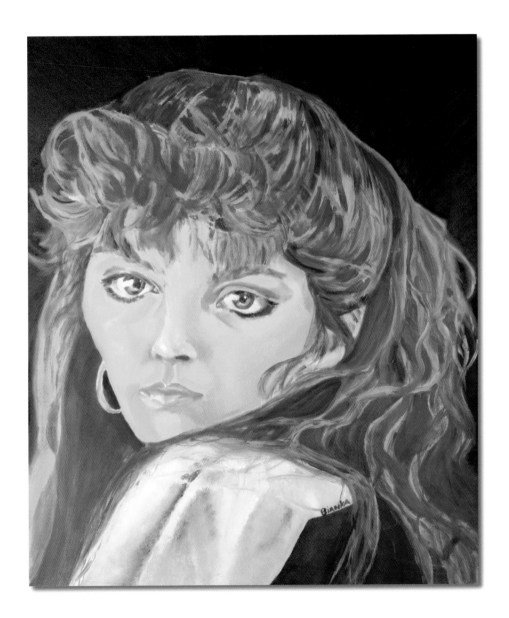

NO VISIBLE MEANS OF SUPPORT
Elizabeth Angelozzi
17" x 19", acrylic on linen
Purchased at a Boston thrift store
MOBA catalog #240

Pink carnations defy gravity in this unlikely still life. Free from the constraints of their vase, the flowers stand independently tall, proud, and in full bloom.

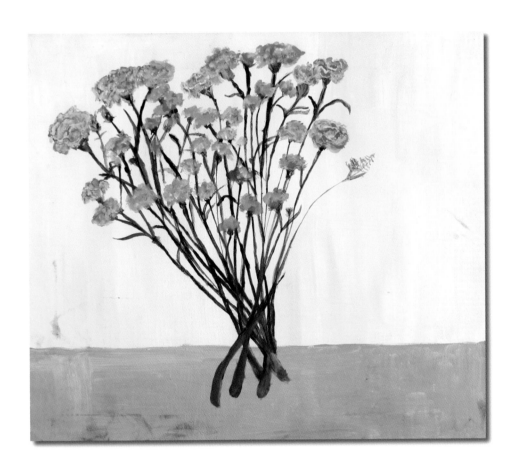

GRAY CUBIST WOMAN
Anonymous
30" x 26". oil on canvas
Purchased at a Jamaica Plain. Massachusetts. thrift store
MOBA catalog #216

Using monochromatic neo-cubist technique, the artist presents a portrait of a sophisticated feminine beauty that simultaneously resembles a young Lauren Bacall and Dolly the Sheep.

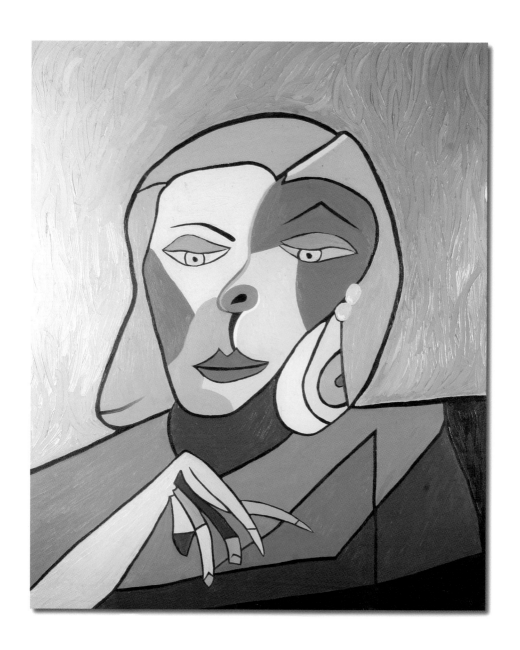

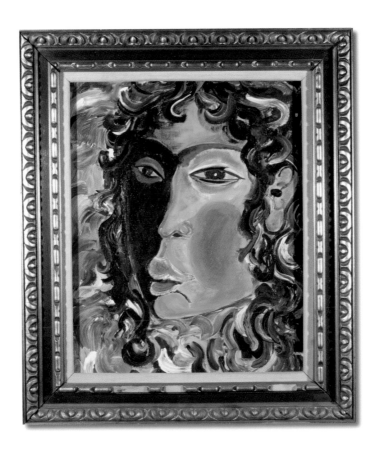

YELLOW AND BLUE PRINCE
Franny (1991)
24" x 18", oil on canvas
Purchased at a Boston thrift store
MOBA catalog #340

This portrait looks suspiciously similar to the artist formerly known as Prince. It works simultaneously as a full-face portrait and a profile of the Purple One wearing his *Phantom of the Opera* mask. Franny spared no paint for this work, which brings to mind the work of Vincent Van Gogh during his LSD period.

Support MOBA

Now that you've learned a bit about the Museum of Bad Art, you will surely want to help us fulfill our important mission. There are a number of ways to do that.

- Visit us on the web at www.MuseumOfBadArt.org or in person in the basement of the movie theater outside of Boston. You can even get here by public transportation. Directions are, of course, on our website.

- MOBA's collection and spirits are maintained by the Friends of MOBA. To become a FOMOBA, simply solemnly swear that you will henceforth dedicate your life to the collection, celebration, and exhibition of bad art and that you will support MOBA's principles, uphold its standards, and honor its name. Then send your email address to Info@MuseumOfBadArt.org. You'll receive a free subscription to the email publication *MOBA News*.

- Tell your friends to visit and become FOMOBAs.

- Buy MOBA gifts (and more books) from our gift shop, www.MassBayTrading.com/MOBA.

- Donate cash to help us with our important mission. It's tax deductible!

- Donate your bad art. All submitted work must be original works of art (no reproductions). The pieces that we look

for would never hang in a museum or commercial gallery, yet they have some quality that draws you to them—or perhaps grabs you by the throat and won't let go. Send a photo, along with details about the size, media, and history to Curator@MuseumOfBadArt.org. The curator-in-chief will let you know if your piece belongs in our collection. An initial evaluation can be done from a slide or photo, but if you just want it out of your life, wrap it up and ship it to us. Any pieces not accepted into the permanent collection will be issued an official MOBA Rejection Certificate and subsequently used for educational purposes or sold at auction.

Acknowledgments

The authors gratefully thank Andrea Scott for her invaluable help with the manuscript, Maggie Delgado and Bill Sheppard for the loan of their flamingo painting, Peter Keville for schlepping *Worried Guy* from Seattle to Boston, and Julie Knopp and Ed Sacco for lovingly tolerating our fixation on MOBA and patiently living among the pieces and ever-growing stacks of art it entails.